The Forms of Nameless Things

THE FORMS OF NAMELESS THINGS

Experimental photographs by **William Henry Fox Talbot**

Geoffrey Batchen

BODLEIAN
LIBRARY
PUBLISHING

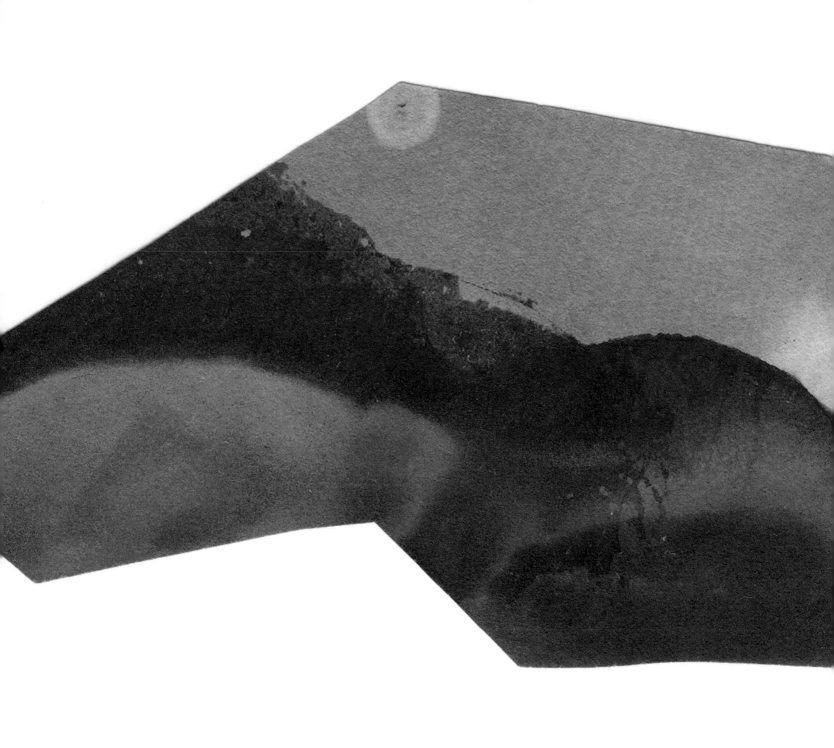

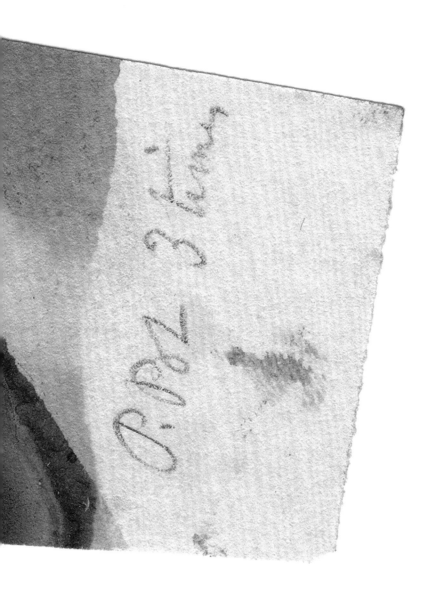

Contents

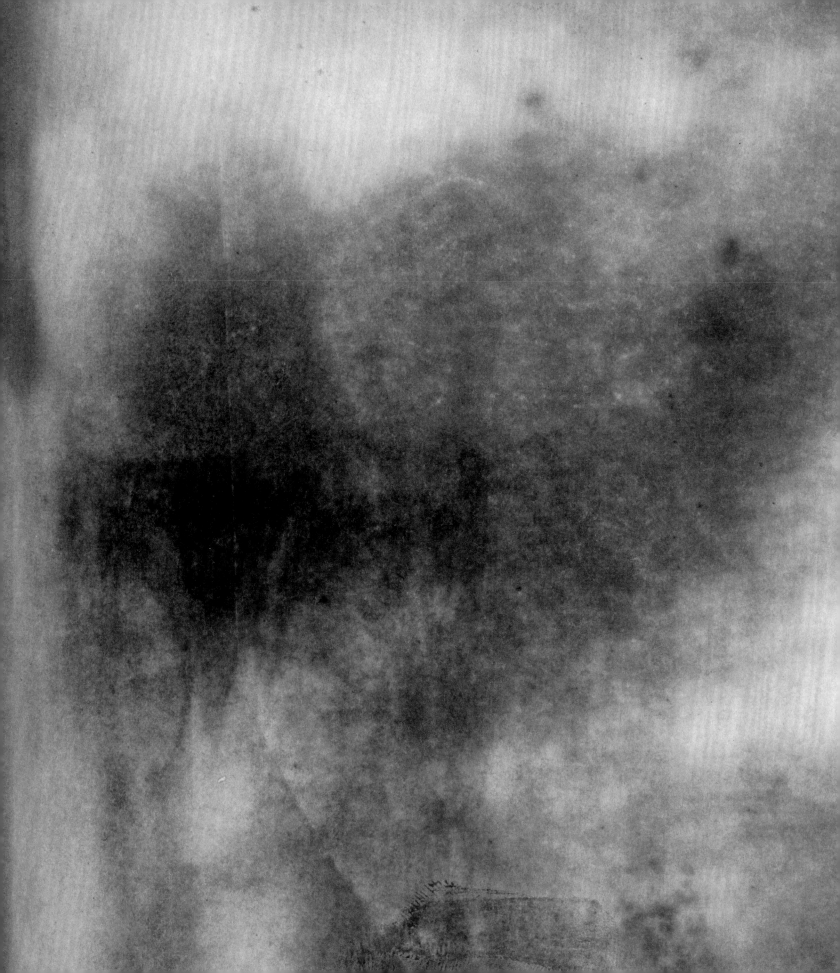

Plates

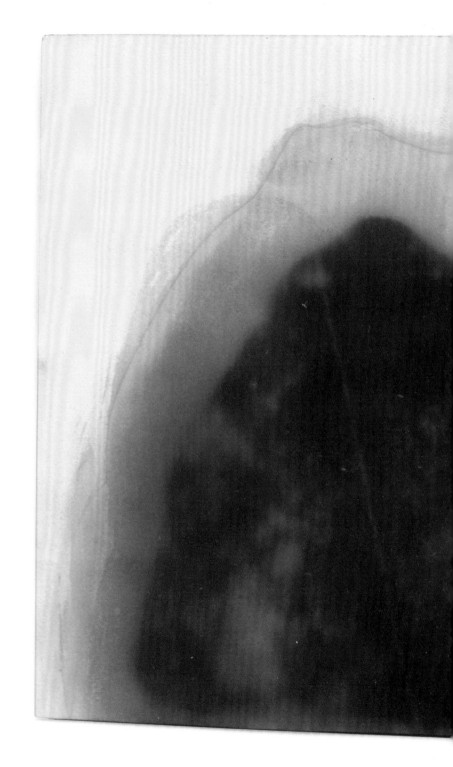

1

William Henry Fox Talbot, *Untitled*
(ribbon, or cloth strip with decorative edge)
[Schaaf 3734], 26 February 1839

Photogenic drawing negative by contact (pencil,
recto, X Feb 26/39)

9.8 × 18.3 cm

Collection of Smithsonian Institution's National
Museum of American History (1995.0206.277)

Feb 26/39

2

William Henry Fox Talbot, *Untitled*
(experimental test strips) [Schaaf 4812], n.d.

Paper negative (possibly partly varnished; in two parts;
pencil rule line along one edge)

1.7 × 5.2 cm

Collection of Smithsonian Institution's National Museum
of American History (1995.0206.401)

3

William Henry Fox Talbot, *Untitled*
(copy of a circular pattern, possibly glass) [Schaaf 5366],
1840s

Salted paper print (mounted on scrapbook page)

8.2 × 9.4 cm

Collection of Snite Museum of Art, University of Notre
Dame (1985.74.14b)

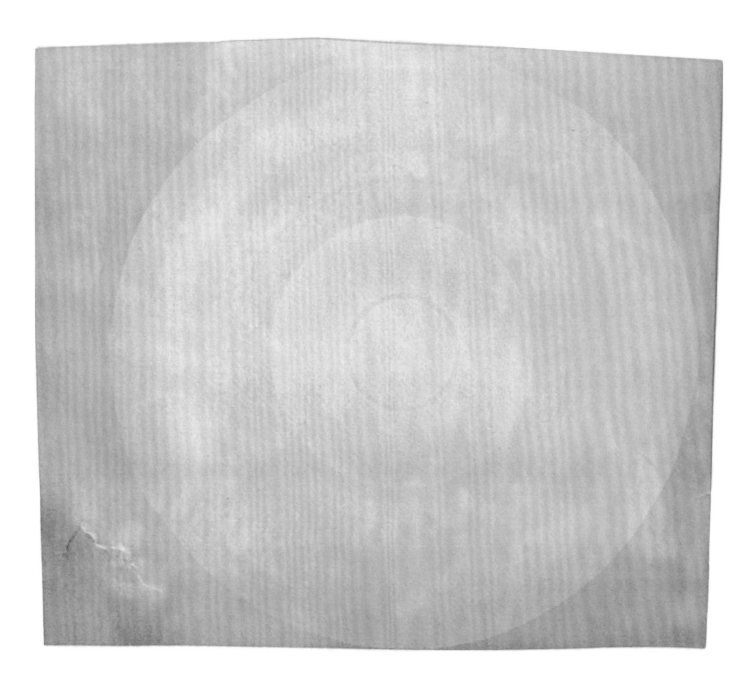

4

William Henry Fox Talbot, *Untitled*
(experimental image, possibly showing the roofline of
Lacock Abbey) [Schaaf 3815], 31 December 1840

Camera-made paper negative (ink, verso, Tm Paper C a 5′
Dec.r. 31/40 [Turkey Mill paper, about 5-minute exposure,
31 December 1840]; pencil, recto, E [possibly – not
clear]/40)

11.2 × 9.5 cm

Collection of Smithsonian Institution's National Museum
of American History (1995.0206.284)

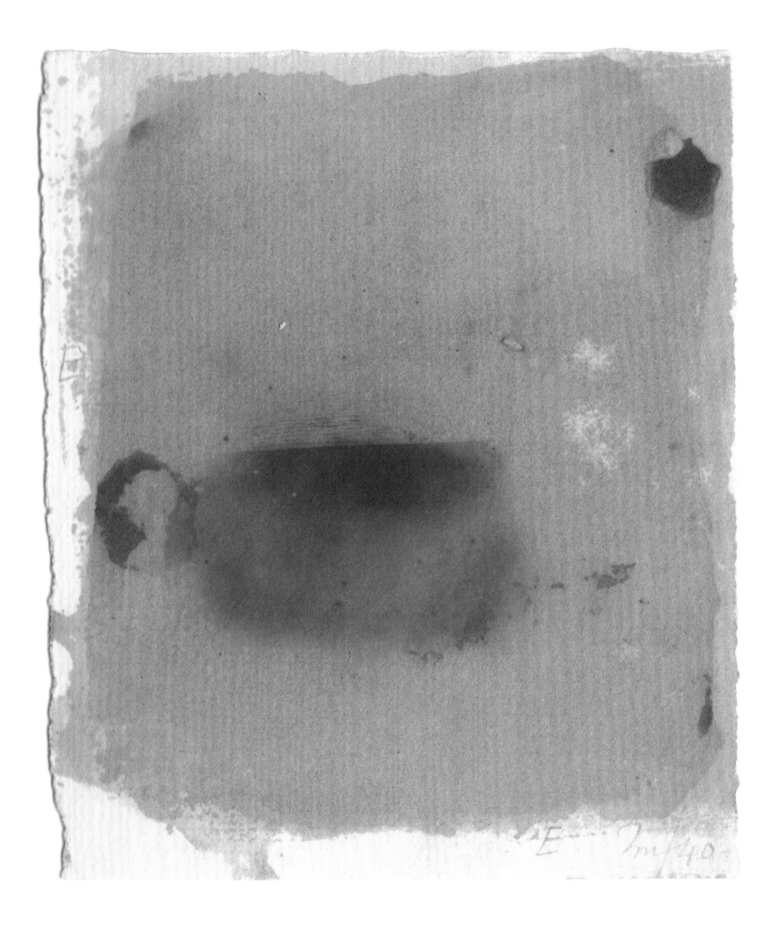

5

William Henry Fox Talbot, *Untitled* (experimental test strip) [Schaaf 4799], n.d.

Paper negative (in pencil, recto, P. Pot 3 times [possibly potash or potassium])

3.2 × 8.4 cm

Collection of Smithsonian Institution's National Museum of American History (1995.0206.306)

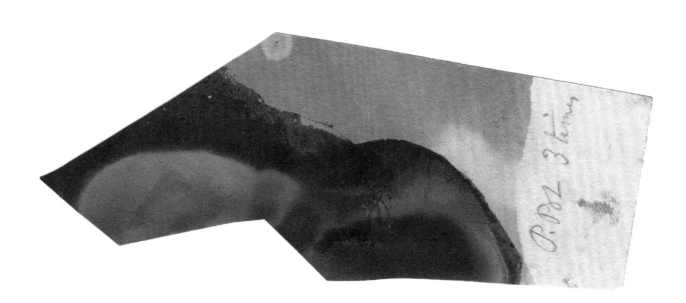

6

William Henry Fox Talbot, *Untitled*
(lace) [Schaaf 2320], December 1839

Photogenic drawing paper negative by contact (in
ink, verso, in Talbot's hand, Exposed to the light for a
month Decr 1839; in pencil, verso, b)

9.5 × 8.8 cm

Collection of J. Paul Getty Museum (84.XM.1002.029)

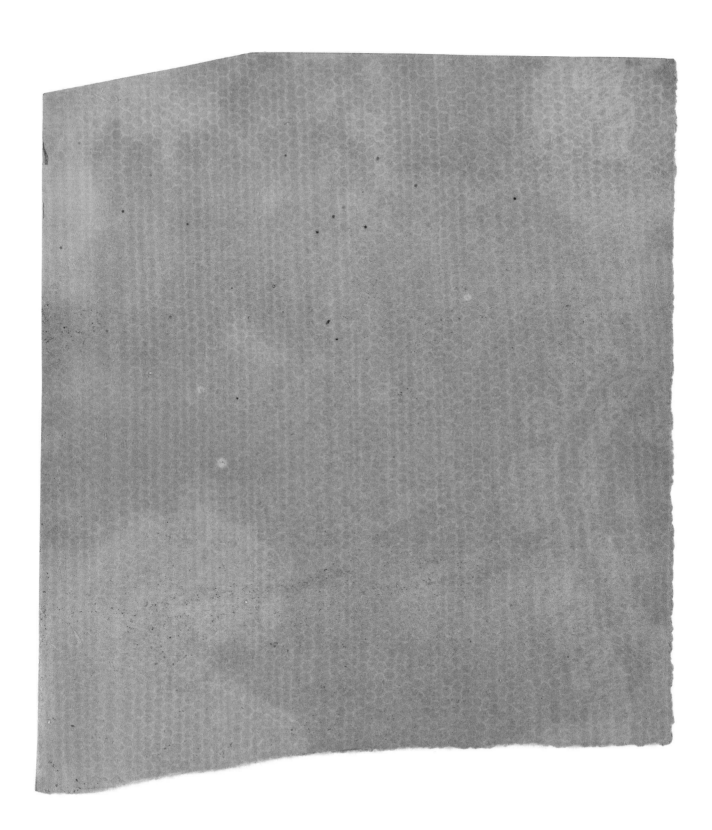

7

William Henry Fox Talbot, *Untitled* (possibly experimental patches) [Schaaf 4892], n.d.

Paper negative (divided in half by a pencil line; pencil X on each side of the line; pencil N recto; traces ruled pencil lines along the edges)

5.4 × 8.7 cm

Collection of Smithsonian Institution's National Museum of American History (1995.0206.607)

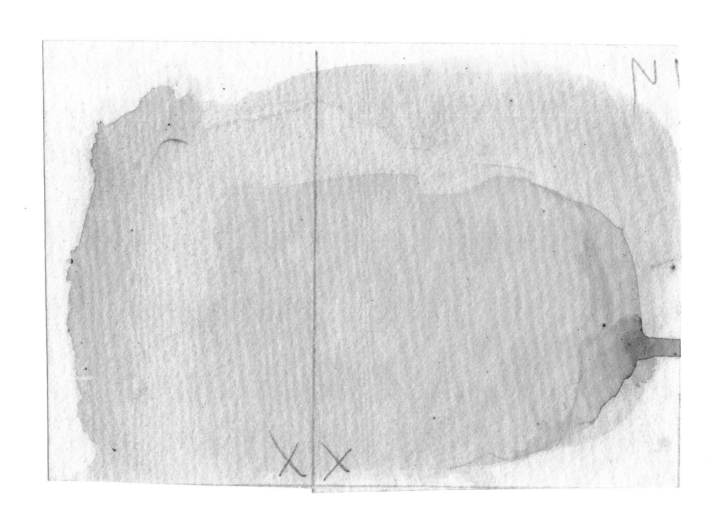

8

William Henry Fox Talbot, *Untitled* (experimental image with sharply delineated density lines) [Schaaf 4870], n.d.

Paper negative (in pencil, recto, N &)

23.2 × 18.7 cm

Collection of Smithsonian Institution's National Museum of American History (1995.0206.542)

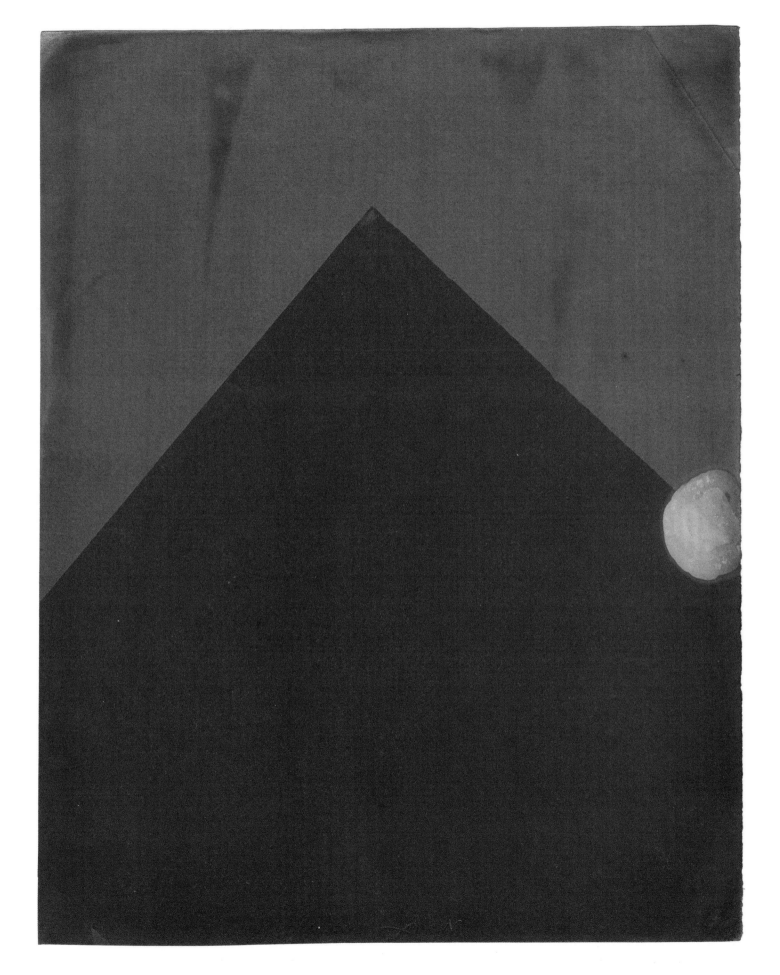

9

William Henry Fox Talbot, *Untitled*
(fragment of a facsimile of an old printed page, as seen in
Plate IX of *The Pencil of Nature*) [Schaaf 3988], n.d.

Paper negative by contact (pencil rule lines along two
edges, recto)

3.9 × 7.2 cm

Collection of Smithsonian Institution's National Museum
of American History (1995.0206.518)

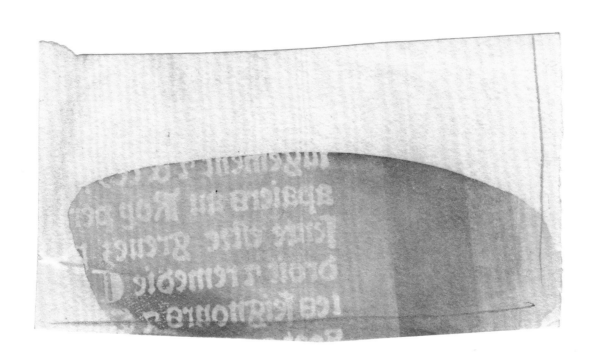

10

William Henry Fox Talbot, *Untitled* (third in a group of twelve experimental test patches) [Schaaf 2816], 18 February 1863

Paper negative by contact (in pencil, verso, Red lead Feb 18 63 [red lead metal, 18 February 1863])

5.3 × 3.5 cm

Collection of National Science and Media Museum (1937-3885/03)

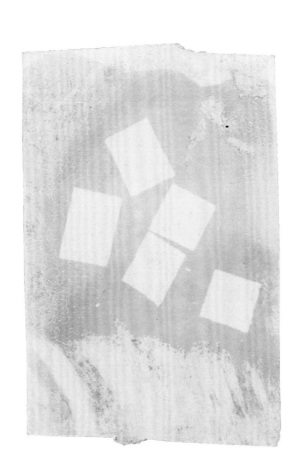

11

William Henry Fox Talbot, *Untitled*
(an experiment towards the calotype) [Schaaf 2468], 22
September 1840

Camera-made paper negative (in turquoise ink, New
paper Sept 22/40 2' fx Iod [New paper, 22 September
1840, 2-minute exposure, fixed, Iodine]; in pencil, Sept 23
washed with E & brought out by spont.)

9.5 × 11.5 cm

Collection of The British Library (Talbot Photo 3(35))

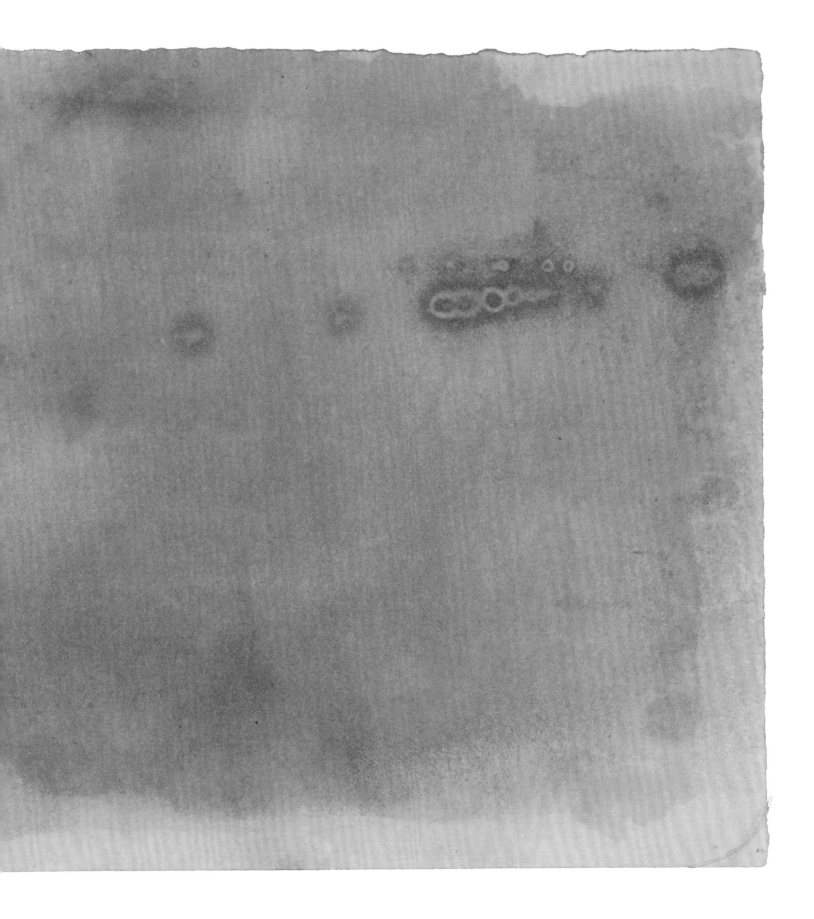

12

William Henry Fox Talbot, *Untitled* (experimental test strip) [Schaaf 4798], n.d.

Paper negative (in pencil, recto, Str. Salt left in; pencil line down middle)

11.3 × 1.3 cm

Collection of Smithsonian Institution's National Museum of American History (1995.0206.305)

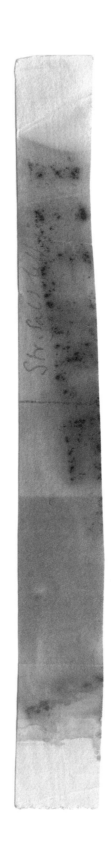

13

William Henry Fox Talbot, *Untitled* (south front of
Lacock Abbey) [Schaaf 4163], 28 February 1840

Salted paper print (in pencil, recto, D or 4th copy; in
pencil, recto, 28 Feb/40 [28 February 1840])

18.7 × 22.9 cm

Collection of Victoria and Albert Museum
(RPS025108)

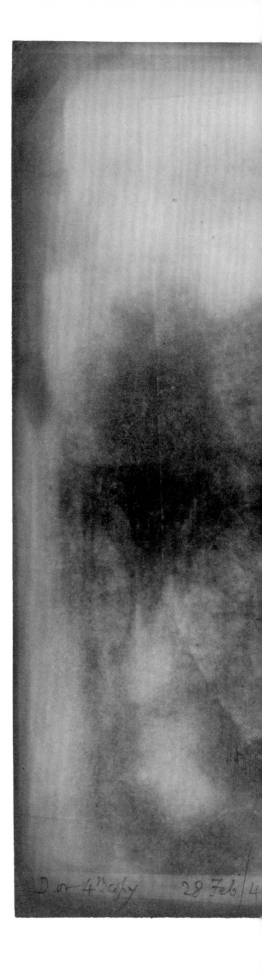

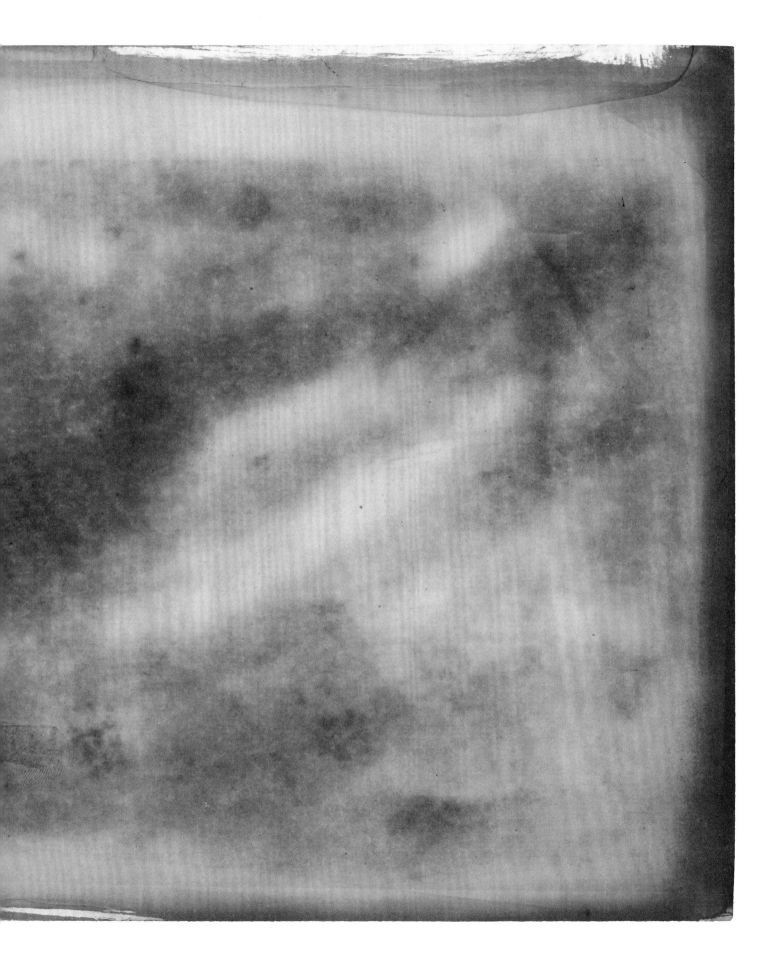

14

William Henry Fox Talbot, *Untitled* (possibly an experimental negative composed of ten small views on glass) [Schaaf 850], nd

Paper negative (contact print)

11.3 × 9.3 cm

Collection of National Science and Media Museum (1937–3793)

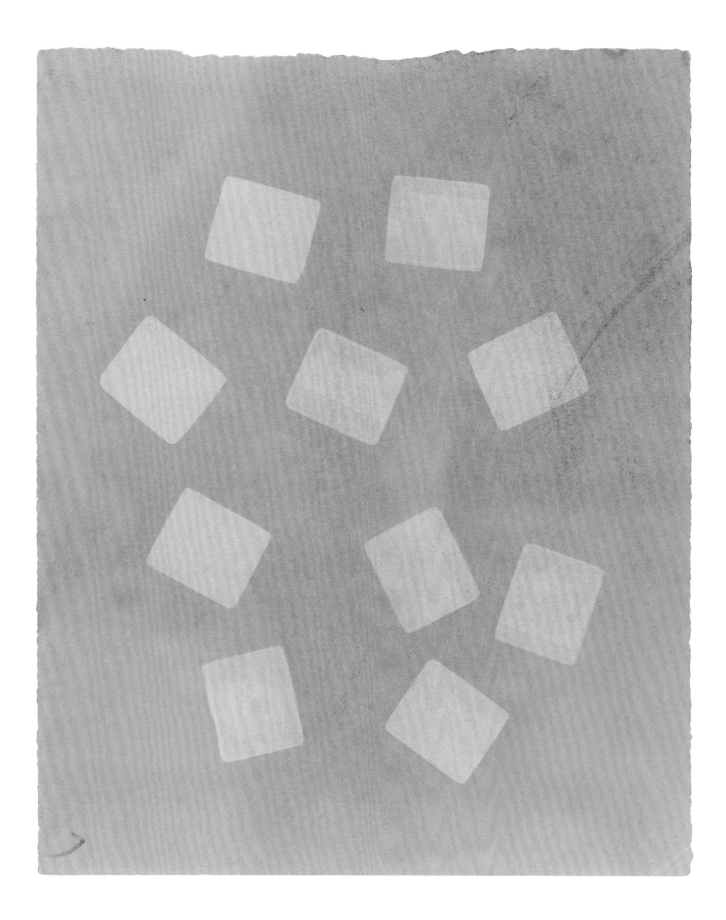

15

William Henry Fox Talbot, *Untitled* (experimental
example – streaks of colours) [Schaaf 4876], n.d.

Paper negative (pencil X recto; traces of ruled pencil
lines along the edges, recto)

12.0 × 18.4 cm

Collection of Smithsonian Institution's National
Museum of American History (1995.0206.563)

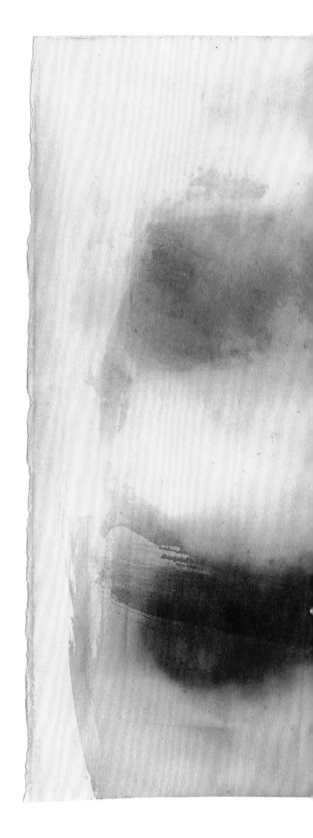

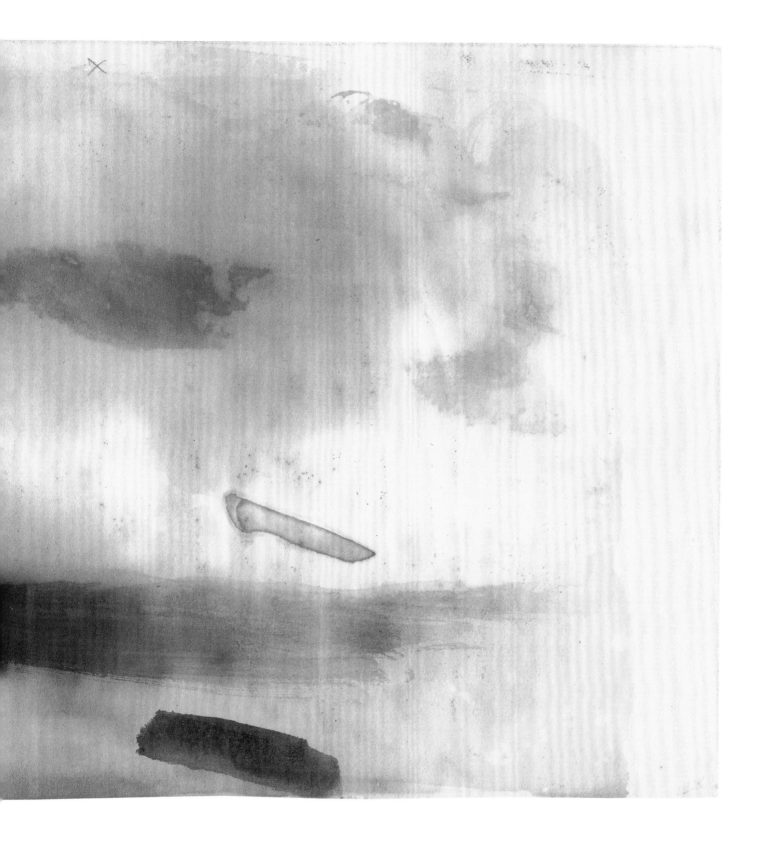

16

William Henry Fox Talbot, *Untitled* (first in a group
of twelve experimental test patches) [Schaaf 2815]
17 February 1863

Paper negative by contact (in pencil, verso, No 1 Feb 17
17 Feby 1863 [Number 1, February 17, 17 February 1863])

6.1 × 3.8 cm

National Science and Media Museum (1937-3885/01)

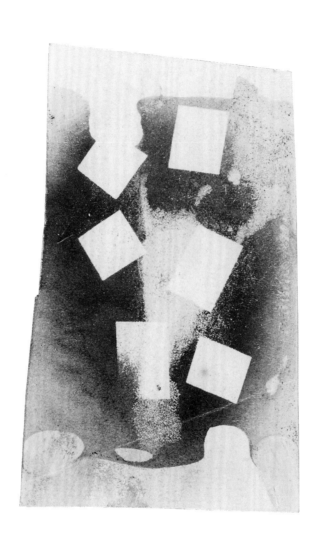

17

William Henry Fox Talbot, *Untitled* (three rectangles)
[Schaaf 4395], n.d.

Leucotype on paper (pencil rule lines along two edges;
one ragged edge; fingerprints)

7.8 × 5.6 cm

Collection of The British Library (Talbot Photo 3(162))

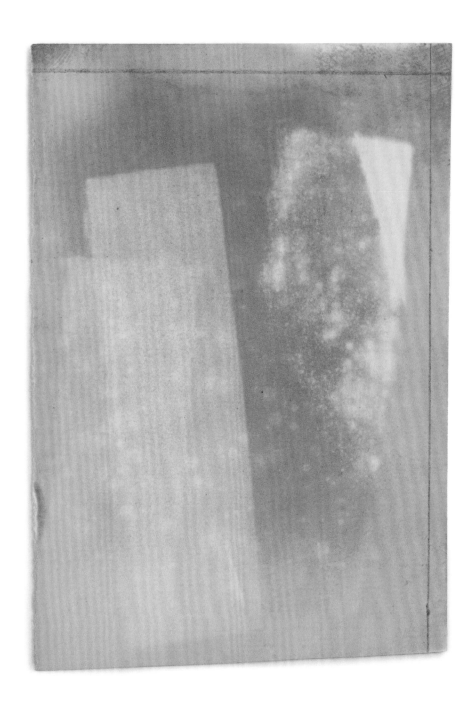

18

William Henry Fox Talbot, *Untitled*
(an experimental image of a clubmoss) [Schaaf 3720],
n.d.

Paper negative (in ink, recto, This side Iod / then wash'd
This side wash'd / then Iod" [This side Iodine, then
washed / This side washed, then Iodine])

15.8 × 12.0 cm

Collection of Smithsonian Institution's National Museum
of American History (1995.0206.260)

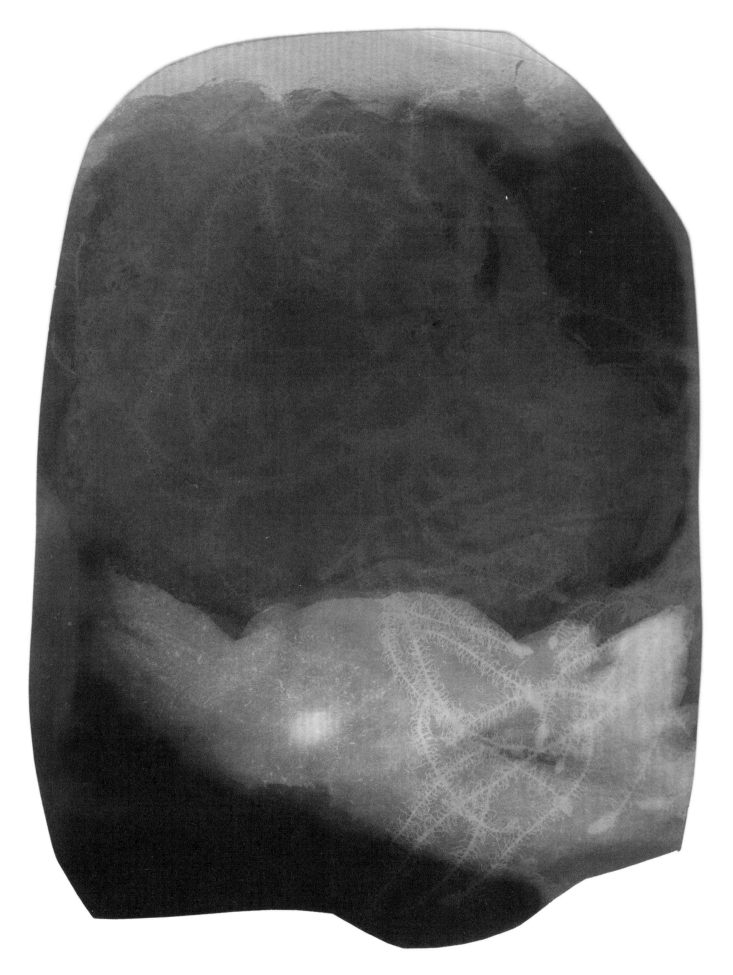

19

William Henry Fox Talbot, *Untitled* (interior view of a window) [Schaaf 4270], n.d.

Camera-made paper negative (irregular pencil line along one edge)

3.0 × 4.1 cm

Private collection

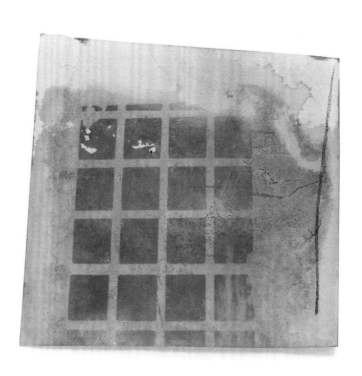

20

William Henry Fox Talbot, *Untitled* (experimental test of four different states of silver bromide) [Schaaf 3912], n.d.

Paper negative (in ink, verso, 4 different states Brom. Silver [silver bromide])

2.5 × 2.4 cm

Collection of Smithsonian Institution's National Museum of American History (1995.0206.388)

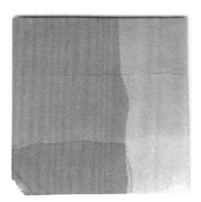

21

William Henry Fox Talbot, *Window in the tower of Lacock Abbey*
[Schaaf 5242], n.d.

Salted paper print (in ink verso: Window in the Tower of Lacock Abbey; in pencil verso: M.T.T.; in pencil verso: JT and TH (possibly TM))

17.8 × 16.6 cm

Collection of Bodleian Libraries, University of Oxford (Dep. d. 996, fol. 39r)

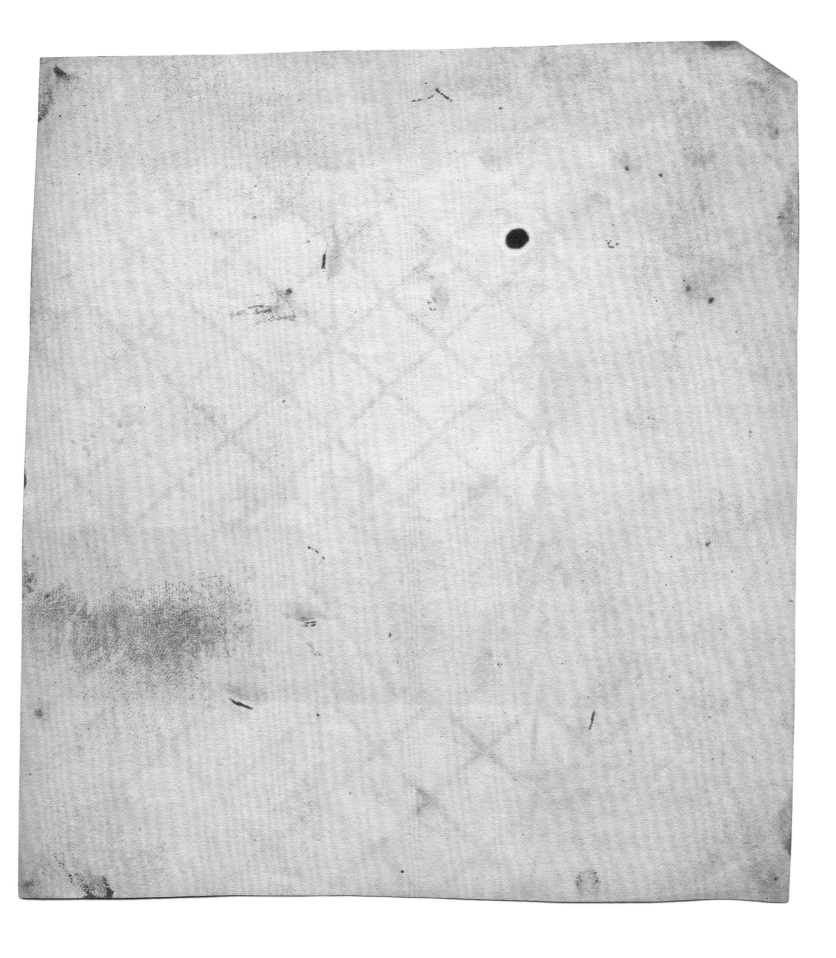

22

William Henry Fox Talbot, *Untitled* (image indecipherable) [Schaaf 4481], n.d.

Paper negative (pencil rule lines, recto; uneven or incomplete chemical coating; uneven edges with one corner tab folded over on itself, twice)

7.6 × 6.3 cm

Collection of The British Library (Talbot Photo 3(77))

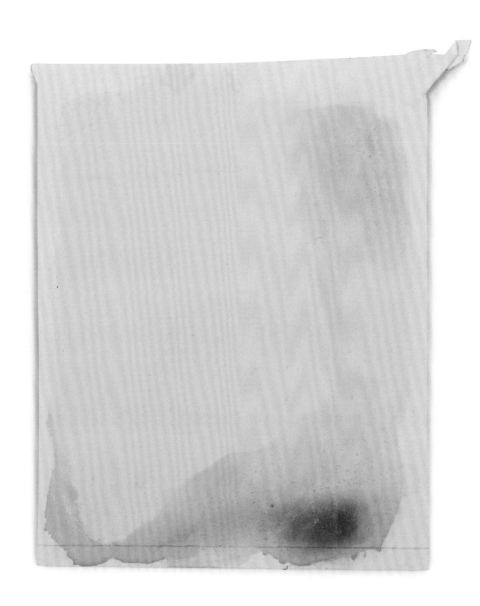

23

William Henry Fox Talbot, *Untitled* (interior of a window, experimental photograph) [Schaaf 2119], n.d.

Camera-made paper negative

10.5 × 7.3 cm

Collection of National Science and Media Museum (1937-1571)

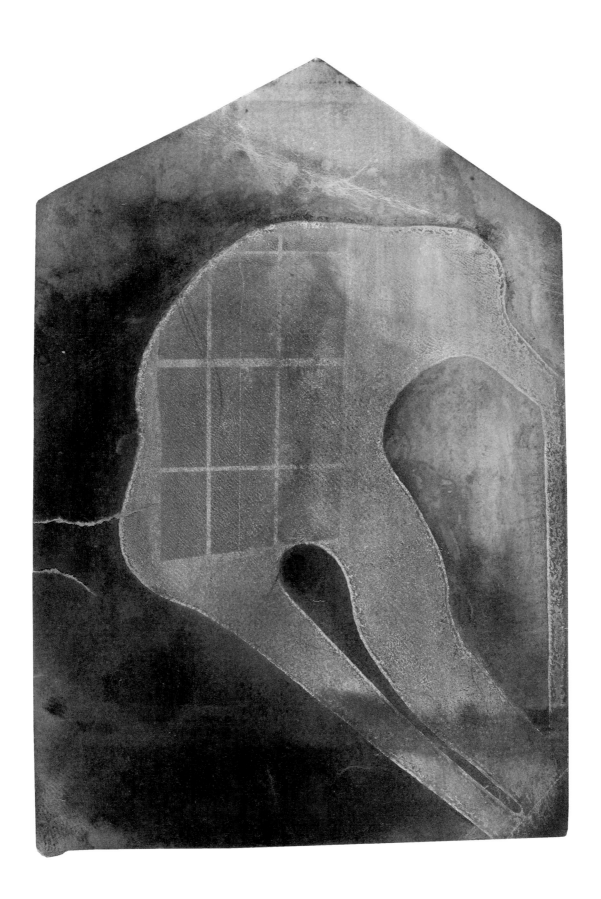

24

William Henry Fox Talbot, *Untitled* (image indecipherable
– rectangular shape) [Schaaf 3903], n.d.

Paper negative (pencil X recto; pencil line, recto)

8.1 × 4.5 cm

Collection of Smithsonian Institution's National Museum
of American History (1995.0206.464)

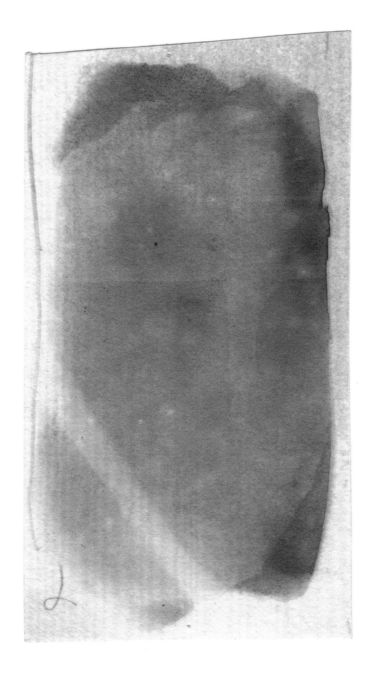

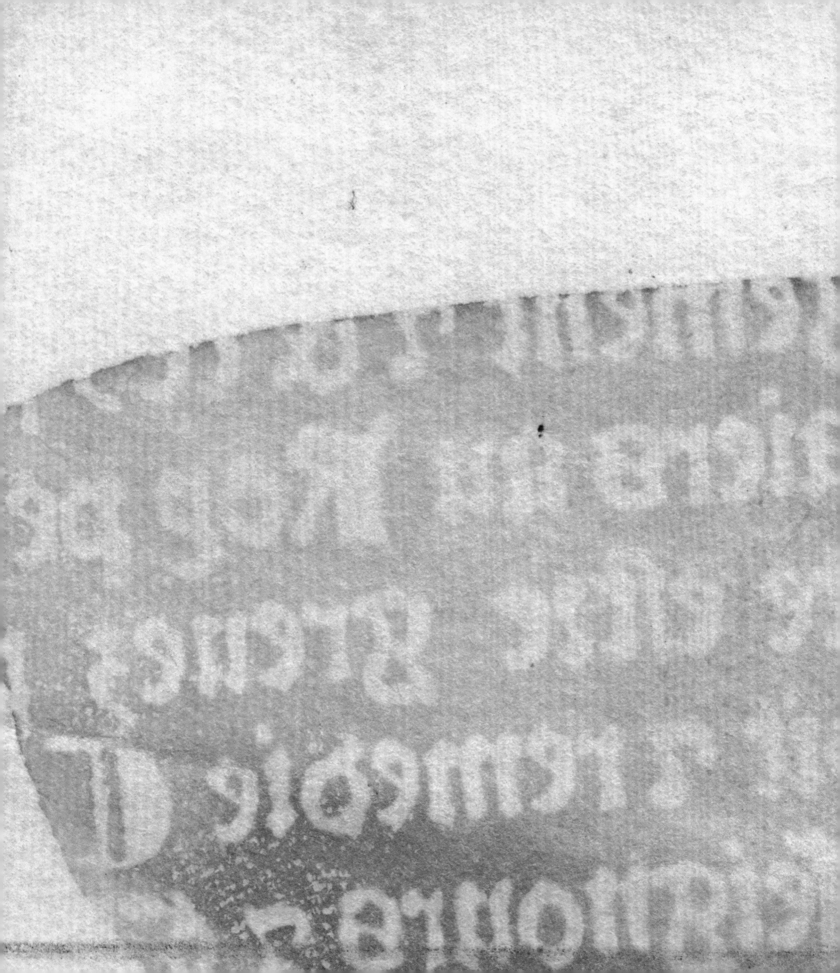

The Forms
of Nameless
Things

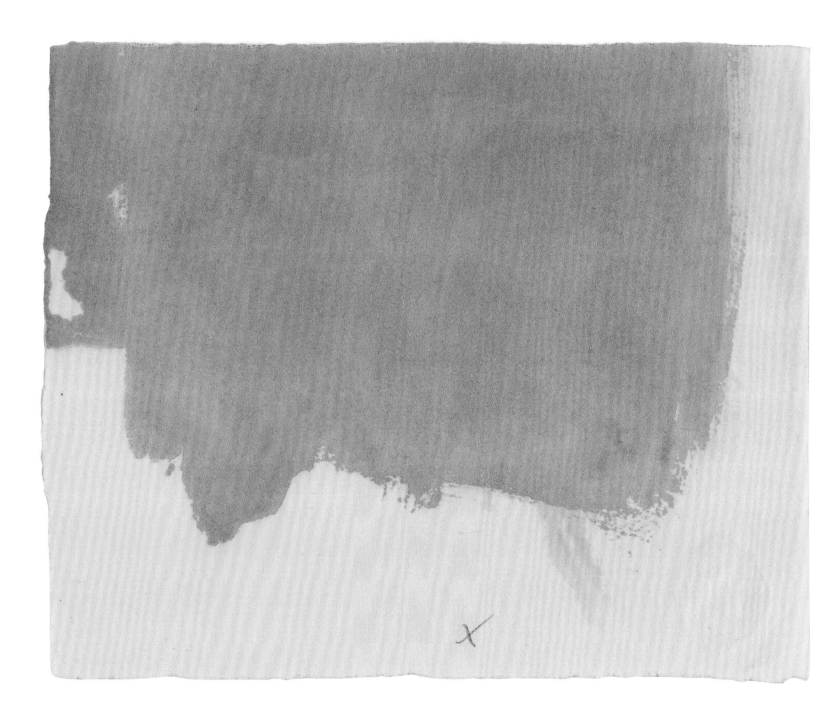

orrowing its intriguing title from an 1830 poem written by William Henry Fox Talbot, the English inventor of photography, this book features a selection of twenty-four of his least familiar photographs. Made between the 1830s and 1863, these photographs are what we might today call test prints or, depending on their morphology and function, test strips. In most cases, they are experimental photographs where any image has been obscured, obliterated or simply failed to register. All that remains on his pieces of light-sensitized paper, originally intended by Talbot as creative exercises or scientific trials, or both, are chemical stains and imprinted patterns or shapes. Offered here as enigmatic physical artefacts of interest in their own right, these proto-photographs also prove themselves to be objects of beauty, mystery and promise, works that speak of photography's most fundamental attributes and potentials. In short, it is proposed that this is a kind of photography that is all about photography itself; it is a photography that enacts 'an erasure which allows what it obliterates to be read'.[1]

There are about 15,000 photographs attributed to Talbot, most of them attempts on his part to produce compelling pictorial records of the world around him. Understandably, existing accounts of his career tend to reproduce the best (and best preserved) of these photographs. But Talbot also undertook a lot of private investigations of photographic chemistry during that career, and made numerous tests to perfect his various processes and techniques. In other words, to make good photographs he first had to take imaginative risks, try new things and produce a certain number of informative failures. This book showcases just a few of these marginal photographs. The selection is intended to be representative of the different kinds of photographic experiments Talbot undertook. But it also offers some glimpses of those strange beauties he thereby managed to produce, the 'forms of nameless things' that he once conjured within his prophetic pre-photographic poem 'The Magic Mirror'.[2]

Fig. 1
William Henry Fox Talbot (1800–1877),
Untitled (image indecipherable)
[Schaaf 4797], c.1840s?
Paper negative (inscription: pencil X recto)
9.3 x 10.5cm
Collection of Bodleian Libraries, University of Oxford (MS. WHF Talbot photogr. 2, fol. 16r)

Nothing but photography

An interesting element of Talbot's character was that he threw nothing away. No matter how modest the result, be it no more than a scrap of inscribed photographic paper or a blank sheet bearing no discernible image, he kept it for future reference. For him, these were obviously all *photographs*, whether or not they were successful as pictures in conventional terms. Often, he added pencil inscriptions to remind himself of what the experiment had been or cut the piece of paper into an irregular shape to reuse what remained. The end result is a collection of photographic odds and ends, bits of photograph that consist of nothing but photography.

Appearing to be abstractions, these are in fact as realist as photographs get, eschewing all illusion in favour of the medium's most essential feature: the activation of light-sensitive chemicals soaked into a two-dimensional substrate. No matter what else they might be, they are photographs that are always about this, about their own inherent photographicness. This is no small thing. To look at these photographs is to get a sight of a primeval moment in the medium's history; we get to witness its coming into being. But, in stripping photography back to first principles, Talbot's experimental detritus also speaks directly to the concerns and interests of the present. In an era of digital imaging, in which the photograph appears to have become an ephemeral and immaterial apparition, the physical capacities of analogue photographs are suddenly a matter of intense interest. Indeed, when examined in this context, Talbot's early photographs transcend their origins in the mid-nineteenth century and invite us to consider what they might have to say today.

Talbot began making photographs in 1834, following his failed attempts to draw the landscape he witnessed during his belated honeymoon in Lake Como in Italy. By the middle of that year, he was sending examples of his experiments to friends and family members. On 12 December, for example, his sister-in-law Laura Mundy wrote to thank him for the 'beautiful shadows' she had recently received from him: 'I had no idea the art could be carried to such perfection – I had grieved over the gradual disappearance of those you gave me in the summer & am delighted to have these to supply their place in my book.'[3] This perfection was unfortunately only temporary, as Talbot had not yet discovered a means of preventing his photographs from continuing to develop in response to light and go black. These earliest prints therefore hovered somewhere between life and death; perversely, the very light needed to see them proved fatal to their

continued visibility. In a sense, Talbot's struggle to overcome this shortcoming was a struggle with mortality itself.

It was one of the many struggles in which he engaged in his laboratory over the next decade or more to improve the permanency, clarity, colour and speed of his new invention. In his first formal essay about photography, written in January 1839, Talbot argued that the systematic trials he undertook, and the improvements in the process they enabled, provided 'a new proof of the value of the inductive methods of modern science'.[4] This helps to explain Talbot's mode of working, a combination of close observation, applied knowledge and repeated experimentation with different chemicals, exposure times, applications and conditions until he was able to achieve a suitably predictable result. It also helps to explain the existence in his archive of numerous 'bad' photographs.

Those photographs vary considerably in size, appearance and manner of production. Some have been exposed in a camera; many have not. Some are photogenic drawings (Talbot's earliest process); some are later calotype negatives or salt prints. A number of them comprise nothing but thin strips of paper that seem to have been dipped or bathed in light-sensitive chemicals, thereby inducing a diversity of mottled primary colours. Other examples are marked by what look like monochrome stains, streaks or blots, their chemical blemishes appearing in the matted fibres of Talbot's paper as if by accident, without symmetry or apparent purpose. In contrast to these, some prints display distinct patterns of circles, grids or mesh, or boast strident geometries such as a floating square or rectangular shapes, or a single dark chevron filling the picture plane. One photograph offers varied shades of blue, the effect of being treated with four different states of silver bromide. Another tantalizes with a glimpse of fragmentary historical text, a smattering of incomprehensible Norman French coming into visibility within a displaced lozenge of sepia chemistry. Defying easy description, this is a photography gone wild, a photography out of the photographer's control.

A particularly remarkable series consists of twelve 'test patches' that Talbot produced in February 1863, about seventeen years after he had taken his last known picture with a camera. Discouraged by the uneven fading of the photographs printed for the June 1846 issue of the *Art-Union* and for his book *Sun Pictures in Scotland*, Talbot more or less abandoned photography. He instead concentrated his energies and intellect on the invention of processes that would allow permanent ink-on-paper photomechanical engravings to be printed. In October 1852 he filed

a patent for what he called 'Photographic Engraving'. In April 1858, having found a way to introduce an aquatint ground to the process, he filed another patent for an improved system of photogravure which he called 'Photoglyphic Engraving'.[5] These are the kinds of picture he henceforth made; until, that is, this brief period in 1863. Exposed on different days within the month of February (with some dated in pencil 17, 18, 20 or 21 February and others left undated), the photographs he produced look like sprayed stencils, featuring a number of white shapes scattered irregularly across the granular texture of his paper. Some sheets are of a dark colour and others exhibit a yellowy tone, suggesting that different chemical compounds were used. Why were they made? What did their repetition, over several days, signify to their maker? We don't know and probably never will.

What we do know is that some of Talbot's test prints were exposed to light for one minute, others for a month. These differences in duration give the resulting photographs a similarly diverse temporal character. None of them could be called instantaneous. At least one has been partially varnished but most display a matt surface, so that the paper substrate remains a visible aspect of the final object. Many of these objects are articulated with pencil additions, including lines, crosses and annotations in shorthand. This means they are part photograph, part drawing. Both nature (clubmoss) and culture (lace) have been allowed to leave their imprints on these photographs, as if there is no distinction between them. Equally, whether or not the referent is a sheet of glass or the inside of a building, everything is reduced in these pictures to an equivalent two-dimensionality, to just so many assorted lines and painterly smears on a flat plane.

Themselves and nothing more

In each case, we are asked to look *at* these photographs rather than through them to something that lies beyond. They are themselves and nothing more. They come to us as murkily opaque surfaces resting stolidly in the present, traces of actions that once took place directly on the paper itself. These photographs are self-declared as *made* rather than taken. In other words, they argue against the prevailing conception of photography as a medium devoted to the automatic capturing of images of a world outside itself.

For many historians, therefore, these are not important photographs (for many, they barely qualify as photographs at all). Notable for not representing anything in particular, Talbot's test prints evade interpretation – except in terms of their

difference from the Talbot photographs we usually celebrate. We value those photographs for the evidence they provide of his hard-won mastery of the physics and chemistry necessary for the successful propagation of analogue photography. We marvel at the range of shadows and textures Talbot was sometimes able to capture with his relatively primitive camera. And we bask in the familiar pleasures of a one-point-perspective rendering of the world, a rendering that geometrically places us, as its viewers, at the focal point of all that is seen in the photograph. Such a picture unerringly locates us at and as the centre of its universe. It brings the chaos of that universe to order, and seemingly under our jurisdiction. Photographs of this sort reassure us by making the things we see in them knowable and nameable.

Not so these test prints. Offering haphazard stains or an overall pattern, and therefore no singular resting point, they actively decentre the observer, asking us to continually cast our eyes back and forth over the photograph's surface, from edge to edge. Lacking a visual confirmation of a stable position in time and space, these photographs refuse to provide a secure haven for our fragile subjectivity. They don't do what photographs are supposed to do. Nevertheless, as we've heard, they were faithfully preserved by Talbot even if they were never meant for public consumption. Maybe we should keep it that way? In some eyes, they are just so many photographic failures, and therefore something of an embarrassment to the discipline (neither artists nor historians like to acknowledge the possibility of failure).[6] Accordingly, only one of them has been previously reproduced.

Indeed, these examples would have continued to remain invisible except to the most assiduous scholars but for the comprehensive online Talbot Catalogue Raisonné prepared by the eminent American historian Larry Schaaf and hosted by the Bodleian Library at the University of Oxford.[7] They therefore come to us now adorned with Schaaf's speculative captions (Talbot rarely provided his own titles or descriptions) and some invaluable explanatory notes. The hesitancy of these captions is striking, utilizing conditional words like 'possibly' or confessional ones like 'image indecipherable' to indicate just how much we don't know about them (including even what caused their patterning or colours). One finds them in the Catalogue by searching for the word 'experimental'. This is another indication of their presumed exceptionality in Talbot's *oeuvre* and the enduring uncertainty as to their motivation and mode of manufacture.

Exceptional they may be, and yet the test print has always been a basic, even essential, element of photographic practice. Such experiments were once

commonplace in darkrooms and studios, those places where photographs used to be produced, but where they were also imagined, assessed, transformed, rejected, reprinted, found wanting and destroyed. In such places, the ruined or bad photograph has been a staple of photographic labour. It is what often comes first, for a photograph is frequently made and remade many times, and in many versions, before one of those versions is declared ready for display or distribution. Photography is, after all, an art of informed guesswork and strategic editing. To make most analogue photographs, a negative is placed in an enlarger, test strips are exposed and an ideal image is envisaged. One then makes print after print, trying this approach or that, until the optimal appearance of the photograph has been decided. Most of these preliminary steps towards the final photograph are discarded shortly after their appearance, unwanted evidence of uncertainty, of the hesitations and hard work that lie just below the pristine surface of any given photograph. These hesitations, and that labour, are thereby rendered invisible to history.

A history of test prints

Fortunately, however, some photographers, like Talbot, have taken the trouble to preserve their test prints, allowing for a truncated account of such work to be attempted. For example, both John Herschel and Hippolyte Bayard, pioneers of the photographic medium in England and France respectively, retained many of their own earliest experiments. These were often exposed side by side, or gathered in albums or notebooks, to allow for comparative analysis. Some of them display hints of an image, but many are nothing but swathes of chemical colour, evidence of latent light sensitivity but little else.[8] Often, these patches of colour were extensively annotated or surrounded by explanatory text. In 1839 or 1840, when these exposures were made, every photograph was a rare memento of the medium's potential for existence. Each of them therefore represented 'photography' in microcosm. Once that medium was established, the need for such evidence diminished and relatively few experimental test prints were retained by later photographers.

Julia Margaret Cameron was unusual in this regard. Using wet collodion glass-plate negatives, she was notorious for her unorthodox printmaking. In one case, for a work she titled either *Sappho* or *Adriana*, depending on the print, she made positive photographs from an 1866 glass negative, even though it was broken. In another case, she allowed rivulets of collodion to merge with the drapery worn by her figures, enhancing the dreamy, ethereal quality of the overall image. In some

Fig. 2
Hippolyte Bayard
(1801–1887), *Cahier d'Essais*,
January 1839, p. 1
Direct positive photographs in album
22.8 × 31.0 cm (album page)
Société Française de Photographie, Paris

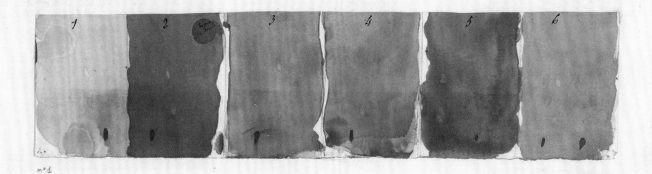

N.º 1

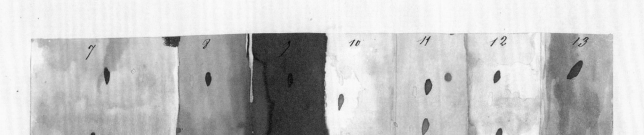

N.º 2

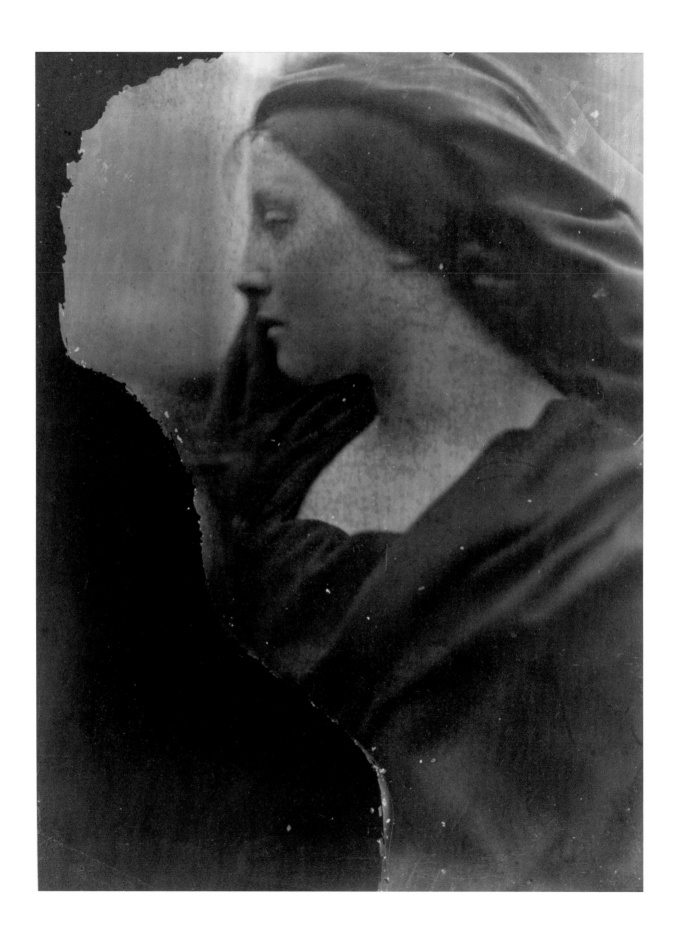

works, a crackling of the collodion on her negatives, 'beyond any power to arrest', resulted in a honeycomb pattern extending over the surface of her albumen prints.[9] Problems like these were not confined to her work alone, but, unlike other photographers, she was willing to share her mistakes with her friends and patrons. For example, in 1865, at his request, Cameron sent sixty-seven 'defective' photographs to the artist George Watts. These included prints in which figures stand out starkly against black backgrounds, an effect caused by missing collodion. In others, faces swim in swirling chemical mists or are framed by the lines of a cracked negative. These prints might be best understood as unfinished sketches sent to Watts for his critique, but their circulation and retention also demonstrate this photographer's willingness to push her medium beyond its perceived limits.[10]

Avant-garde artists of the early and mid-twentieth century were similarly keen to creatively intervene within the photographic medium in various ways, and provocatively exhibited the results as finished artworks. In effect, the experimental test and the exhibition print were no longer distinguishable. The means to an end had become an end in itself. To make such photographs, artists exposed paper or film to light a second time during development, used multiple negatives to reverse tones or layer images, played with photographic chemistry, and in some cases even melted the emulsion on their negatives before printing.[11] Often, these procedures resulted in the obliteration of a describable image, a gesture calculated—precisely in its overt *rejection* of calculation, of any signs of skill or rationality—to provoke and disturb.

However, despite this facade of radicality, these artists were careful to keep any preliminary attempts and perceived failures to themselves. All signs of effort, of work, of trial and error, remained carefully hidden from public view. Genius and labour, after all, are often regarded as being mutually exclusive. To be taken seriously, it was important for these artists that they were seen to be in control of their photographs from inspiration to production, even when accident and unpredictability were built into the process of their making. Their photographs were designed to present themselves as spontaneous and yet self-certain. Unlike Talbot's experiments, these are photographs that don't aspire to be anything more than what they are.

For obvious reasons, commercial photographers from the same century, such as Richard Avedon or Irving Penn, also zealously eliminated all signs of incompetence or error from their archive. This included any unsuccessful

Fig. 3
Julia Margaret Cameron
(1815–1879), *Mary Hillier*, c.1864–5
Albumen photograph from wet
collodion glass negative
25.5 × 19.8 cm (image)
Victoria and Albert Museum,
London (PH.346-1981)

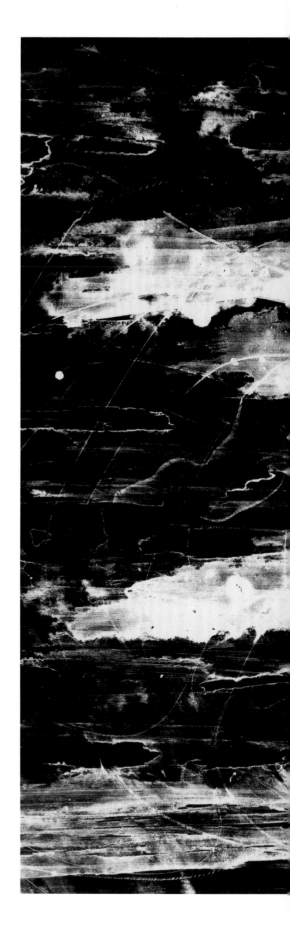

Fig. 4
Bronisław Schlabs
(1920–2009), *Untitled*, 1958
Gelatin silver photograph on
masonite
18.0 × 23.8 cm
Museum of Modern Art, New York
(190.2014)

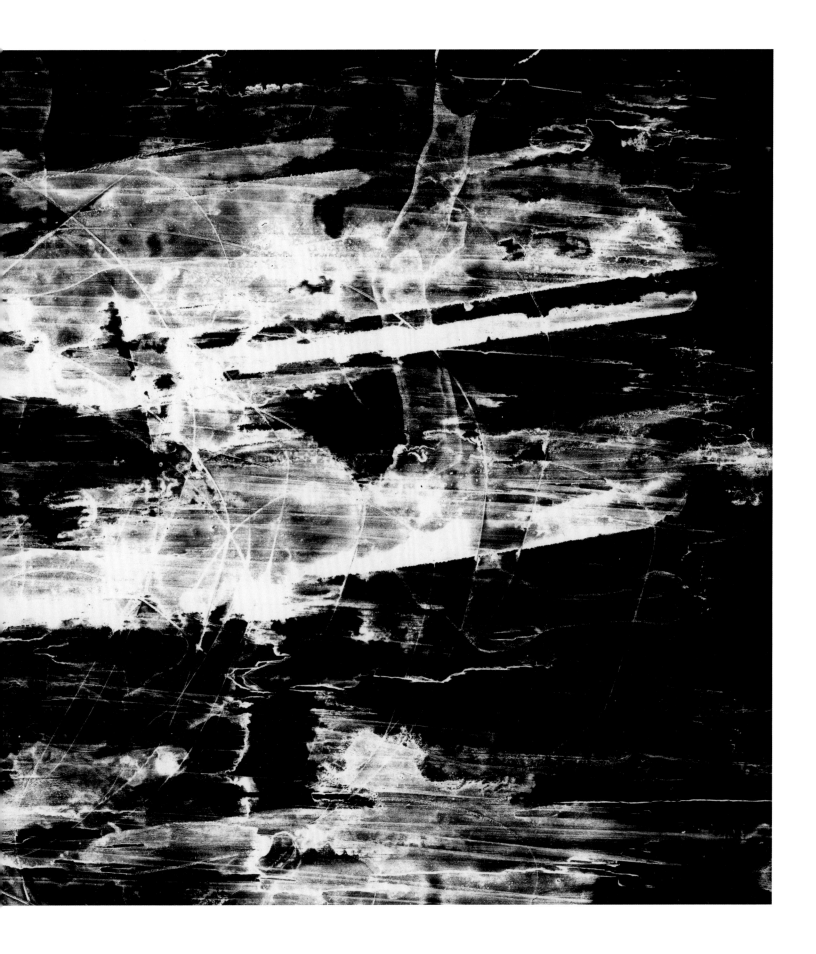

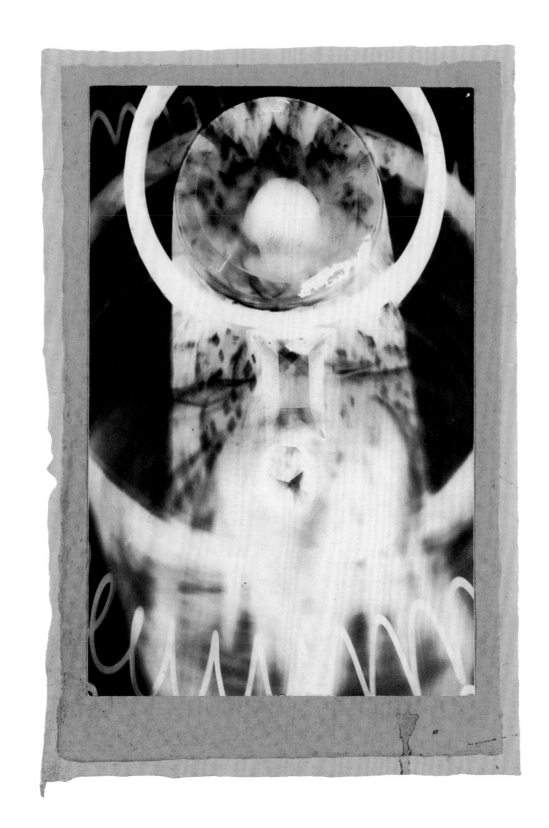

experiments they may have undertaken. What were retained instead are what might be called instructional prints, raw photographs covered in extensive notations intended to guide the manufacture of a master print and its replicas.[12] This practice became particularly necessary in an era when the work of exposing a negative and making a final print were performed by different people.[13] The division of intellectual from manual labour allowed photography studios to mimic the class structure of industrial capitalism. The notation of a test print was, in other words, a consequence of photographic commerce. It was a fundamentally conservative practice, dedicated to ensuring the imposition of a compulsory conformity on every print that was subsequently produced. Nevertheless, these annotated tests do once again signal the constructedness of the photographic process, and therefore the artifice of photography as a medium of representation. By allowing the marginal notes to take over their host, such prints certainly make us think again about what we are looking at.

Quest for knowledge

However, that's not quite the same as the work undertaken by Talbot and others that I have singled out here. If one had to define them, one might say that what distinguishes experimental photographs is they are made without already knowing what the result of the experiment is likely to be; they are a quest for knowledge rather than its reiteration. Motivated by the process of their making, rather than by a desire to produce a specific image, they are steps in a journey to a destination not already identified in advance.

In that sense, at least, the experimental ethos established by Talbot at photography's beginnings has recently come back into fashion, at least among artists. The adoption by some of analogue processes and artisanal printmaking offers a clear contrast with today's post-industrial information economy and its dissipation of the photograph into a myriad of transient electronic signals. The American artist Alison Rossiter, to take one example, buys packets of expired and unexposed photographic paper on eBay, some of it a century old, and then develops and prints that paper. An extended period of accident and serendipity is allowed to determine the look of the resulting photographs.[14] By declining to provide the viewer with a passive reception of an elsewhere once seen by someone else, photography of this kind forces us to think about the activity of seeing taking place in the here and now, confronting us with the consequences of our own perceptual

p. 70
Fig. 5
Man Ray (1890–1976), *Inspiration*, c.1922
Gelatin silver photograph (rayograph) mounted on coloured papers
17.8 × 11.4 cm
George R. Rinhart Collection, United States

p. 71
Fig. 6
Alison Rossiter (b.1953), *Eastman Kodak Velox F4, expired October 1, 1940, processed 2008*, 2008
Gelatin silver photograph
25.3 × 20.2 cm
Collection of Geoffrey Batchen, Oxford

opposite
Fig. 7
Justine Varga (b.1984) installing her exhibition *Photogenic Drawing*, Australian Centre for Photography, Sydney, 2017
Chromogenic photographs pinned on wall
c.300 × 900 cm
Courtesy of the artist, Hugo Michell Gallery, Tolarno Galleries and ACP.
Photo: Michael Waite.

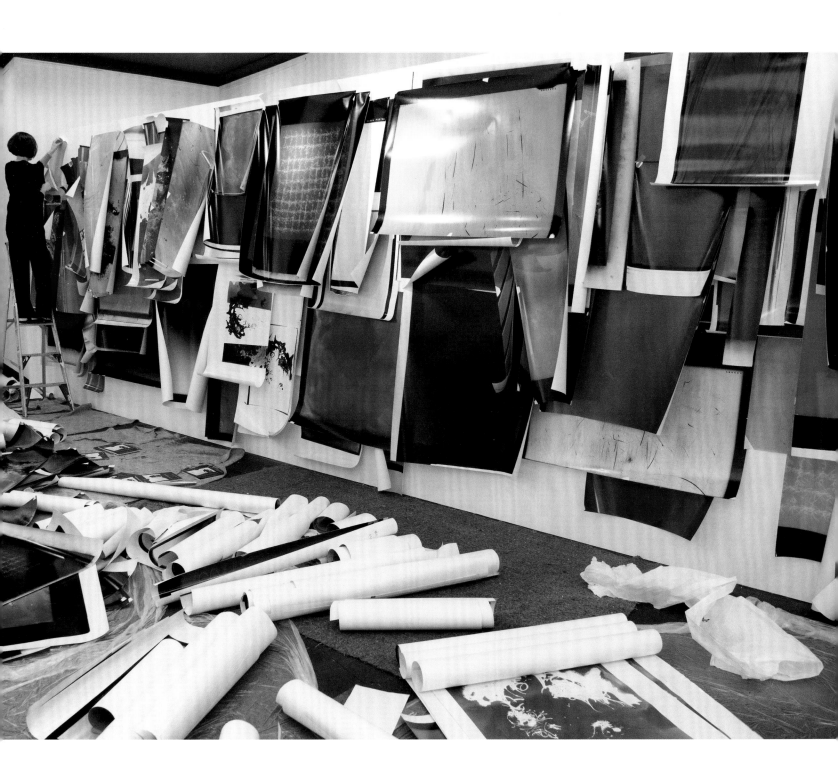

agency. As with Talbot's test prints, these are photographs that turn the act of viewing back onto the viewer, making us, rather than the photographer, the party responsible for their meaning. If we allow it, Rossiter's photographs take us on an unpredictable semantic adventure.

In 2017 the Australian artist Justine Varga offered an even more explicit homage to Talbot's practice. Mounting an exhibition titled *Photogenic Drawing*, Varga took a single wall in an unused retail store and layered it with a dense collage of her own experimental test prints, often torn shreds of paper salvaged from her work in the darkroom.[15] The edges of these recycled pieces of paper obstinately curled off the wall and into our consciousness, collapsing any distinction between image and object, between looking through and looking at. In every aspect, the usual hierarchies were disrupted and the practice of photography turned inside out. Viewers were confronted with what is usually left unseen, the means of production that make possible the luxuriant colour prints for which this artist is known. Daring to reveal the evidence of false starts, dead ends, chromatic variations and orchestrated chance – all necessary steps towards the making of a final photograph – Varga, along with Rossiter and other contemporary artists of like mind, licenses a reappraisal of the foundational work by Talbot seen in this book.

Photography *in potentia*

Produced in private before photography was itself resolved, made while the medium he invented was still in the process of formation, Talbot's exploratory prints place that medium in inverted commas. They offer us a photography permanently *in potentia*, a photography whose future is always still to come. They also insist that photography is a cultural as much as a natural phenomenon, foregrounding our own role in its creation and signification. Refusing to offer a transparent confirmation of the world's perspectival coherence, this is a photography that cannot be used to authorize the continuation of business as usual. Instead, Talbot forces us to reflect on our own expectations of photographs, which his work reveals to be both malleable material things and perennial philosophical dilemmas. Talbot's experiments with photography turn its identity into a question, and ours with it. Bringing the history of that identity full circle, Talbot's test prints displace our habitual complacency in front of these and all other photographs. This is why their serious consideration has never seemed more urgently necessary than it does right now.

Fig. 8
William Henry Fox Talbot, *Untitled* (experimental test strip) [Schaaf 3905], 30 November 1840
Paper negative (pencil rule lines along two edges, recto; pencil, recto, 1"; in turquoise ink, verso, 1" dark weather Nov.30/40 [1 minute exposure – dark weather – 30 November 1840])
2.0 × 5.8 cm
Collection of Smithsonian Institution's National Museum of American History (1995.0206.486)

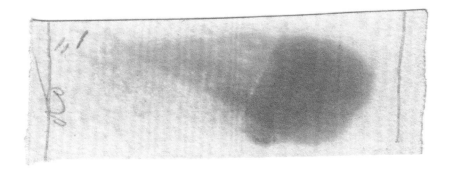

Notes

1 Jacques Derrida, *Positions*, trans. Alan Bass, University of Chicago Press, Chicago, 1981, p. 6.

2 Talbot's 1830 poem 'The Magic Mirror' is transcribed in Mike Weaver (ed.), *The Art of Photography 1839–1989*, Yale University Press, New Haven, 1994, pp. 37–9.

3 Letter from Laura Mundy to William Henry Fox Talbot, 12 December 1834, http://foxtalbot.dmu.ac.uk/letters/letters.html (accessed 20 August 2020).

4 See William Henry Fox Talbot, 'Some Account of the Art of Photogenic Drawing, or, The Process by which Natural Objects May Be Made to Delineate Themselves without the Aid of the Artist's Pencil' (31 January 1839), in Beaumont Newhall (ed.), *Photography: Essays and Images*, Museum of Modern Art, New York, 1980, p. 30.

5 For more on this aspect of Talbot's work, see Larry Schaaf, *Sun Pictures. Catalogue Twelve: Talbot and Photogravure*, Hans P. Kraus, Jr., New York, 2003, and Larry Schaaf, '"The Caxton of Light": Talbot's Etchings of Light', in Mirjam Brusius, Katrina Dean, and Chitra Ramalingam (eds), *William Henry Fox Talbot: Beyond Photography*, Yale University Press, New Haven, 2013, pp. 161–89.

6 For more on this theme, see Kris Belden-Adams (ed.), *Photography and Failure*, Bloomsbury, London, 2017.

7 The William Henry Fox Talbot Catalogue Raisonné: https://talbot.bodleian.ox.ac.uk (accessed 18 August 2020).

8 For the work of John Herschel, see Larry J. Schaaf, *Out of the Shadows: Herschel, Talbot and the Invention of Photography*, Yale University Press, New Haven, 1992. Examples of Hippolyte Bayard's test prints are reproduced in Jean-Claude Gautrand, *Hippolyte Bayard: Naissance de l'image photographique*, Trois Cailloux, Paris, 1986; Michel Poivert, *Hippolyte Bayard*, Photo Poche, Paris, 2001; and *Taches et traces premiers essais photosensibles d'Hippolyte Bayard*, Tipi Bookshop, Brussels, 2016.

9 Cameron, as quoted by Marta Weiss, *Julia Margaret Cameron: Photographs to Electrify You with Delight and Startle the World*, Victoria and Albert Museum, London, 2015, pp. 39–40.

10 See the section 'Her Mistakes Were Her Success' in 'Julia Margaret Cameron's Working Methods', V&A www.vam.ac.uk/articles/julia-margaret-camerons-working-methods (accessed 23 August 2020).

11 For a survey of such work, see Geoffrey Batchen, *Emanations: The Art of the Cameraless Photograph*, DelMonico/Prestel, New York, 2016.

12 See Jane Livingston and Adam Gopnik, *Richard Avedon: Evidence, 1944–1994*, ed. Mary Shanahan, Random House, New York, 1994, and Laura Wilson, *Avedon at Work: In the American West*, University of Texas Press, Austin, 2003.

13 See the discussion of this issue in Geoffrey Batchen, *Negative/Positive: A History of Photography*, Routledge, London, 2021.

14 For more on Rossiter's work, see Leah Ollman, *Alison Rossiter: Expired Paper*, Radius Books/Yossi Milo Gallery, New York, 2017.

15 See 'Photogenic Drawing: Justine Varga', Australian Centre for Photography, https://acp.org.au/see/photogenic-drawing-justine-varga (accessed 2 September 2021); and Daniel Palmer and Martyn Jolly, 'Analogue Materiality', *Installation View: Photography Exhibitions in Australia, 1848–2020*, Perimeter, Melbourne, 2021, pp. 191–6.

Further Reading

Arnold, H.J.P., *William Henry Fox Talbot: Pioneer of Photography and Man of Science*, Hutchinson Benham, London, 1977.

Batchen, Geoffrey, 'A Philosophical Window', *History of Photography*, vol. 26, no. 2, Summer 2002, pp. 100–112.

Batchen, Geoffrey, 'Ruination', *Art Monthly Australasia*, no. 218, April 2016, pp. 38–44.

Brusius, Mirjam, Katrina Dean, and Chitra Ramalingam (eds), *William Henry Fox Talbot: Beyond Photography*, Yale University Press, New Haven, 2013.

Coleman, Catherine, Larry J. Schaaf, Mike Ware, Michael Gray, Geoffrey Batchen, Gerardo F. Kurtz and Russell Roberts, *Huellas de luz: el arte y los experimentos de William Henry Fox Talbot / Traces of Light: The Art and Experiments of William Henry Fox Talbot*, exhibition catalogue, Museo Nacional Centro de Arte Reina Sofia / Aldeasa, Madrid, 2001.

Schaaf, Larry J., *Out of the Shadows: Herschel, Talbot and the Invention of Photography*, Yale University Press, New Haven, 1992.

Schaaf, Larry J., *Records of the Dawn of Photography: Talbot's Notebooks P & Q*, Cambridge University Press, Cambridge, 1996.

Schaaf, Larry J., *The Photographic Art of William Henry Fox Talbot*, Princeton University Press, Princeton, 2000).

Picture Credits

Collection of Geoffrey Batchen, Oxford / © Alison Rossiter and Yossi Milo Gallery, New York: Figure 6

Oxford, Bodleian Libraries, Dep. d. 996, fol. 39r: Plate 21

© British Library / Gift of Janet and Petronella Burnett-Brown / Bridgeman Images, Talbot Photo 3(35): Plate 11; Talbot Photo 3(162): Plate 17; Talbot Photo3(77): Plate 22

Collection of J. Paul Getty Museum, 84.XM.1002.029: Plate 6

Hans P. Kraus Jr. Fine Photographs, New York: Plate 19

Museum of Modern Art, New York (MoMA) © 2021. Gift of the artist, Acc. No. 190.2014. Digital image, The Museum of Modern Art, New York / Scala, Florence. Scala / © 2021 Estate of Bronisław Schlabs, Courtesy of the 9/11 Art Space Foundation: Figure 4

National Science and Media Museum, Science Museum Group, 1937-3885/03: Plate 10; 1937-3793: Plate 14; 1937-3885/01: Plate 16; 1937-1571: Plate 23

George R. Rinhart Collection, from *O Say Can You See: American Photographs, 1839–1939*, MIT Press, Cambridge, MA, 1989 / © Man Ray 2015 Trust / DACS, London 2021: Figure 5

Courtesy of Alison Rossiter: Figure 6

William Henry Fox Talbot Collection, Division of Work and Industry, National Museum of American History, Smithsonian Institution: Figure 1, 8. Plate 1, 2, 4, 5, 7, 8, 9, 12, 15, 18, 20, 24

Snite Museum of Art, University of Notre Dame, Gift of Janos Scholz, 1985.074.014.b: Plate 3

Société Française de Photographie (coll. SFP), 2011, frSFP_0024im_518_H_009 24-ALB-003: Figure 2

Courtesy of Justine Varga, Hugo Michell Gallery, Tolarno Galleries and ACP © The artist. Photo: Michael Waite. © Justine Varga / Copyright Agency. Licensed by DACS 2021: Figure 7

© Victoria and Albert Museum, London, PH.346-1981: Figure 3; RPS025108: Plate 13

Acknowledgements

Any study of the work of William Henry Fox Talbot owes a tremendous debt to the painstaking research of Larry Schaaf, and this one is no different. Indeed, this book is intended as a tribute to, and sampler from, the online Talbot Catalogue Raisonné prepared by Schaaf and hosted by the Bodleian Library at the University of Oxford. Its other inspiration comes from the artistic practice of my partner, Justine Varga, whose creative use of test prints first brought their significance to my attention. Since my arrival at the University of Oxford, I have been fortunate to enjoy the encouragement and support of Bodley's Librarian, Richard Ovenden, as well as the considerable professional expertise of Samuel Fanous, Janet Phillips, and Leanda Shrimpton at Bodleian Library Publishing. I hope the appearance of this book will induce its readers to consult the Talbot Catalogue Raisonné for themselves and thereby become better acquainted with the achievement of the photographer to which it is dedicated.

First published in 2022 by the Bodleian Library
Broad Street, Oxford OX1 3BG
www.bodleianshop.co.uk

ISBN: 978 1 85124 593 2

Publisher: Samuel Fanous
Managing Editor: Susie Foster
Editor: Janet Phillips
Picture Editor: Leanda Shrimpton
Designed and typeset by Dot Little at the Bodleian Library in 10/15 Freight Text
Printed and bound by Gomer Press Limited on 150gsm Arctic matt paper

British Library Catalogue in Publishing Data
A CIP record of this publication is available from the British Library